# Super Simple Flowers

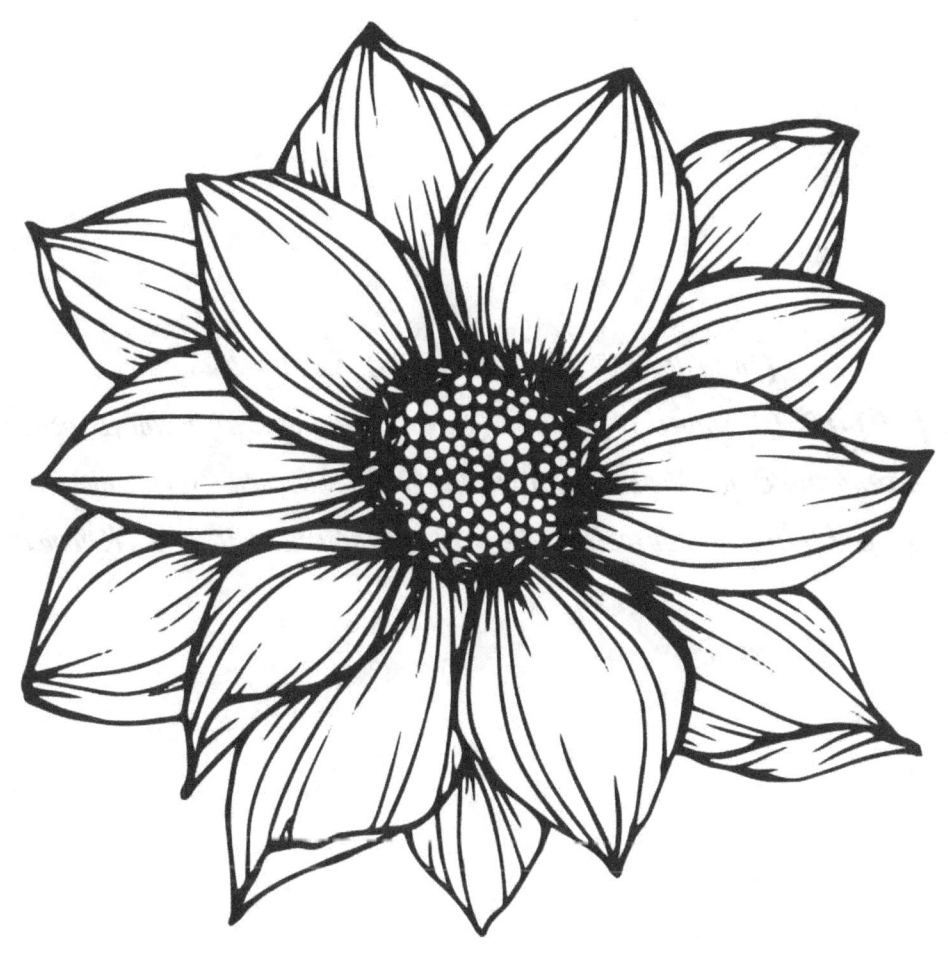

Easy Coloring Book for Adults
A Beginners Beautiful Grayscale Book of Flowers

Copyright © 2019 Coloring Evangelists
All Rights Reserved.  This book or any part of it may not be used in any matter whatsoever without the expressed written permission of the publisher except for the use of brief quotations in a book review

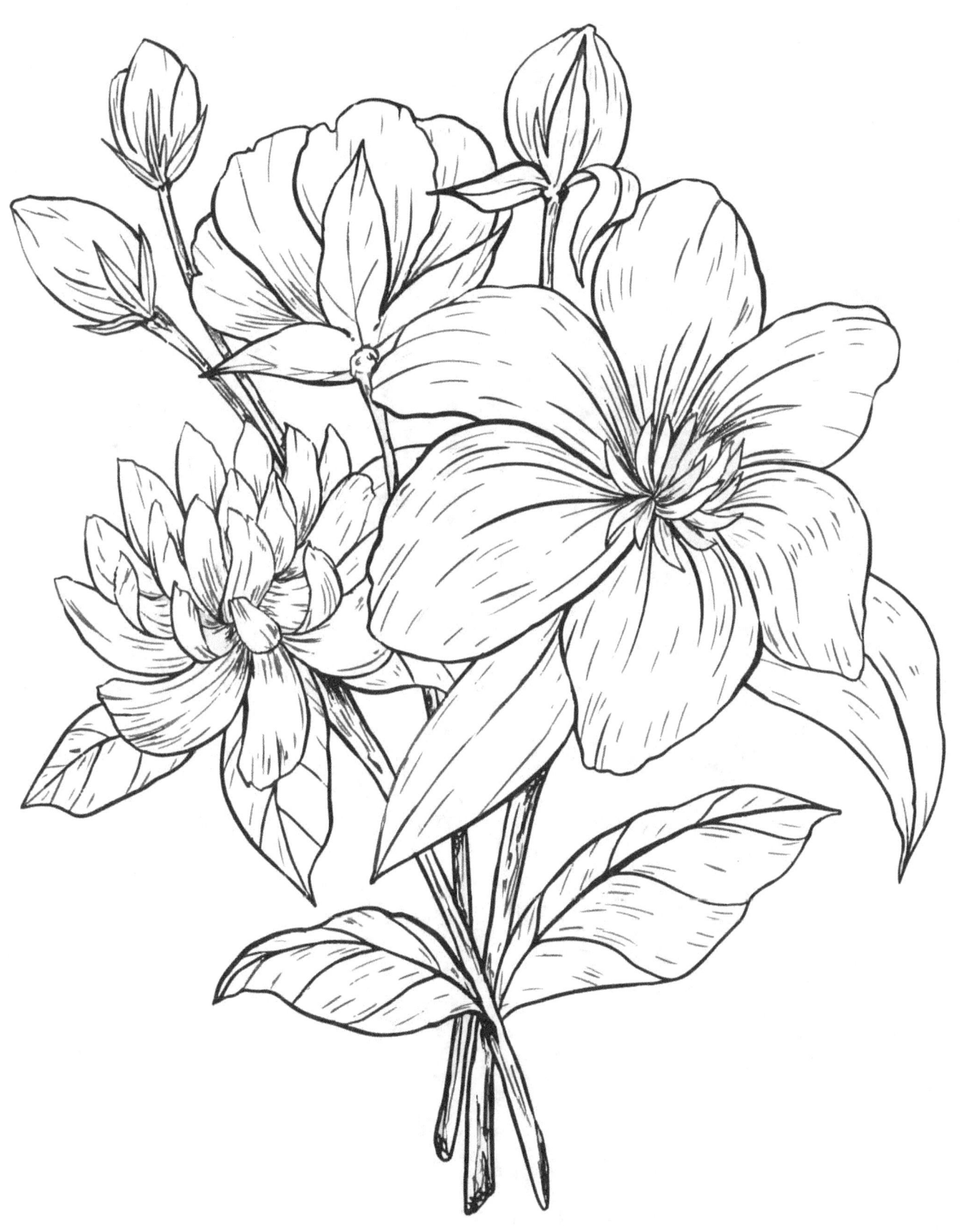

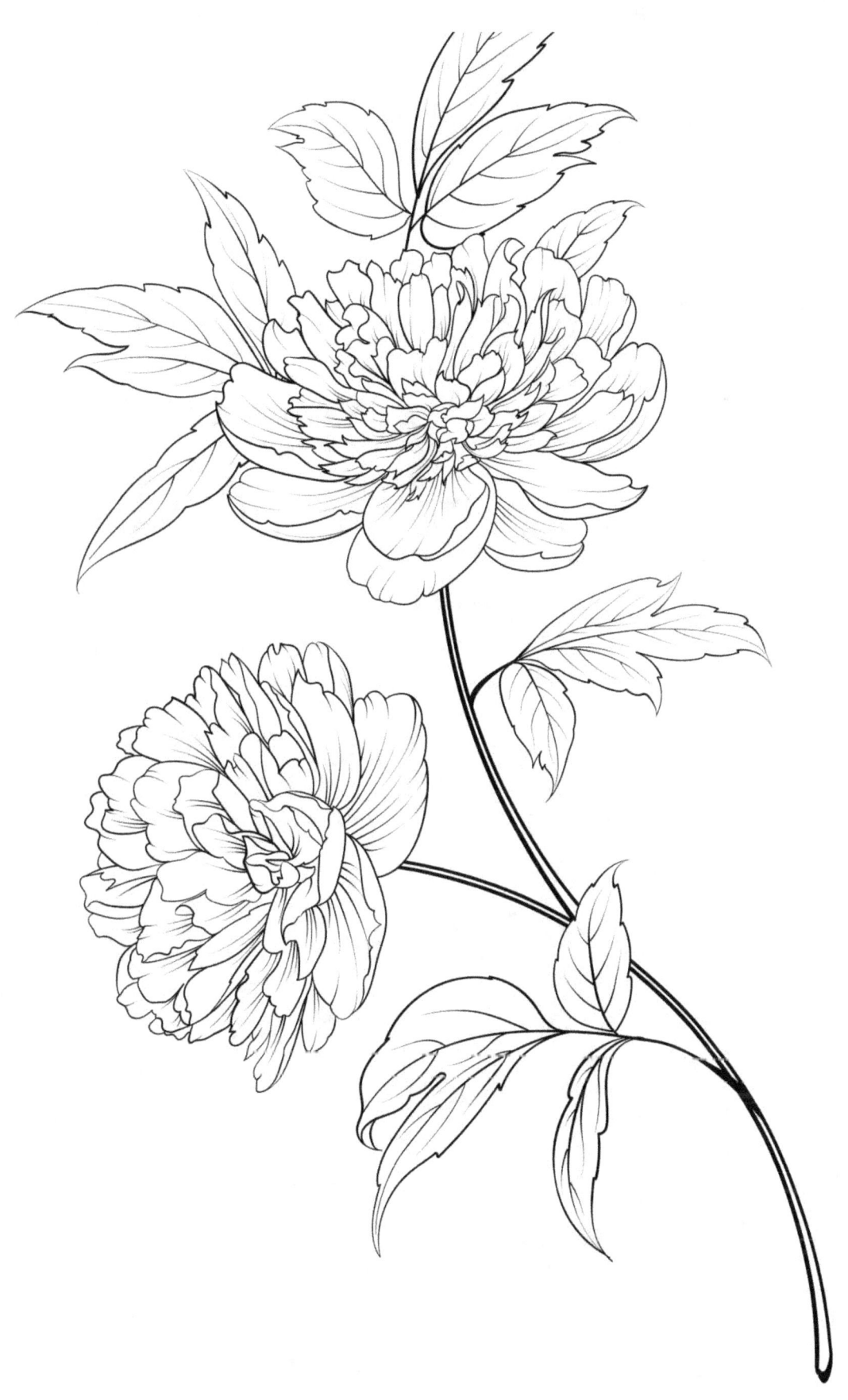

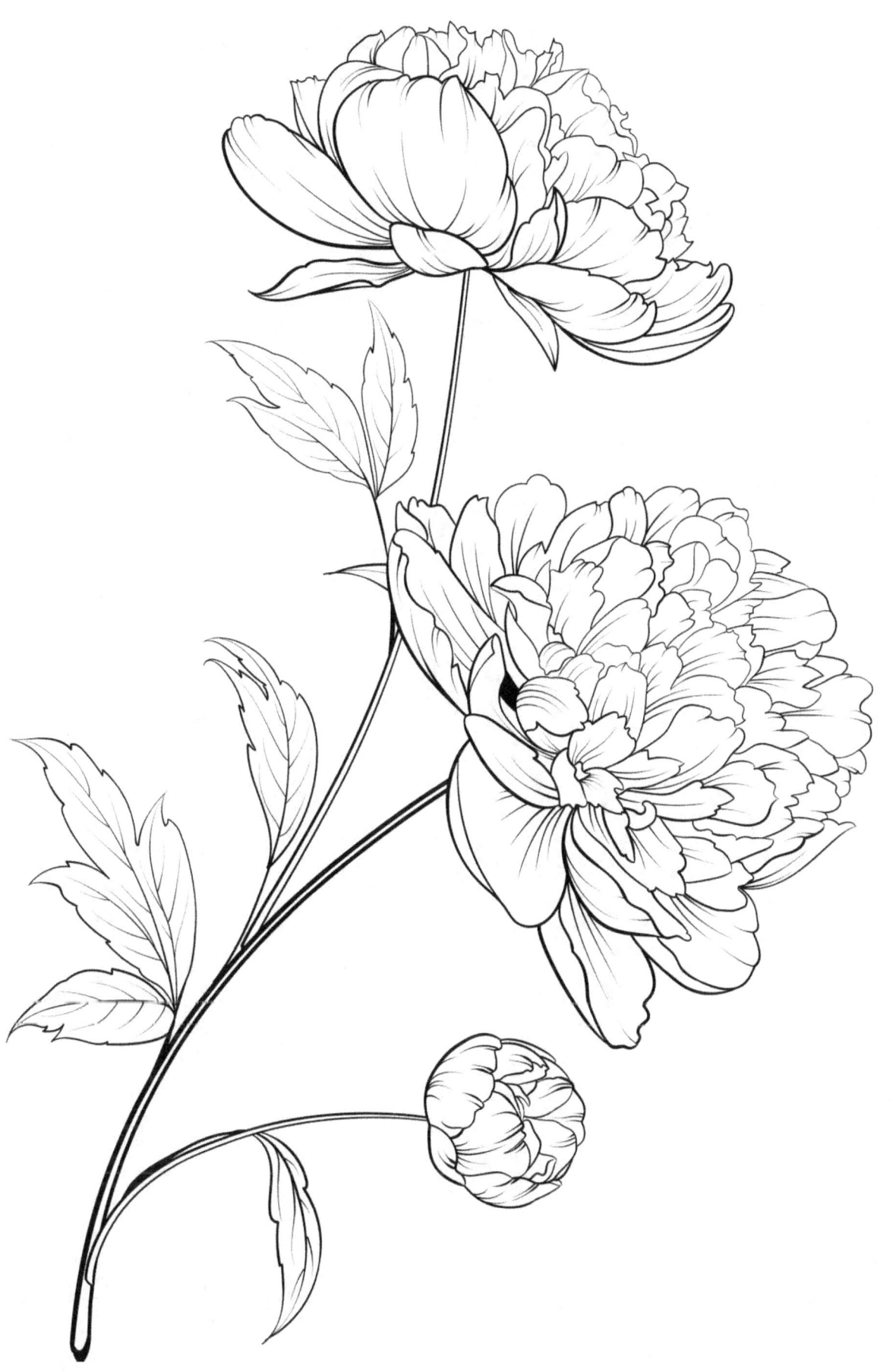

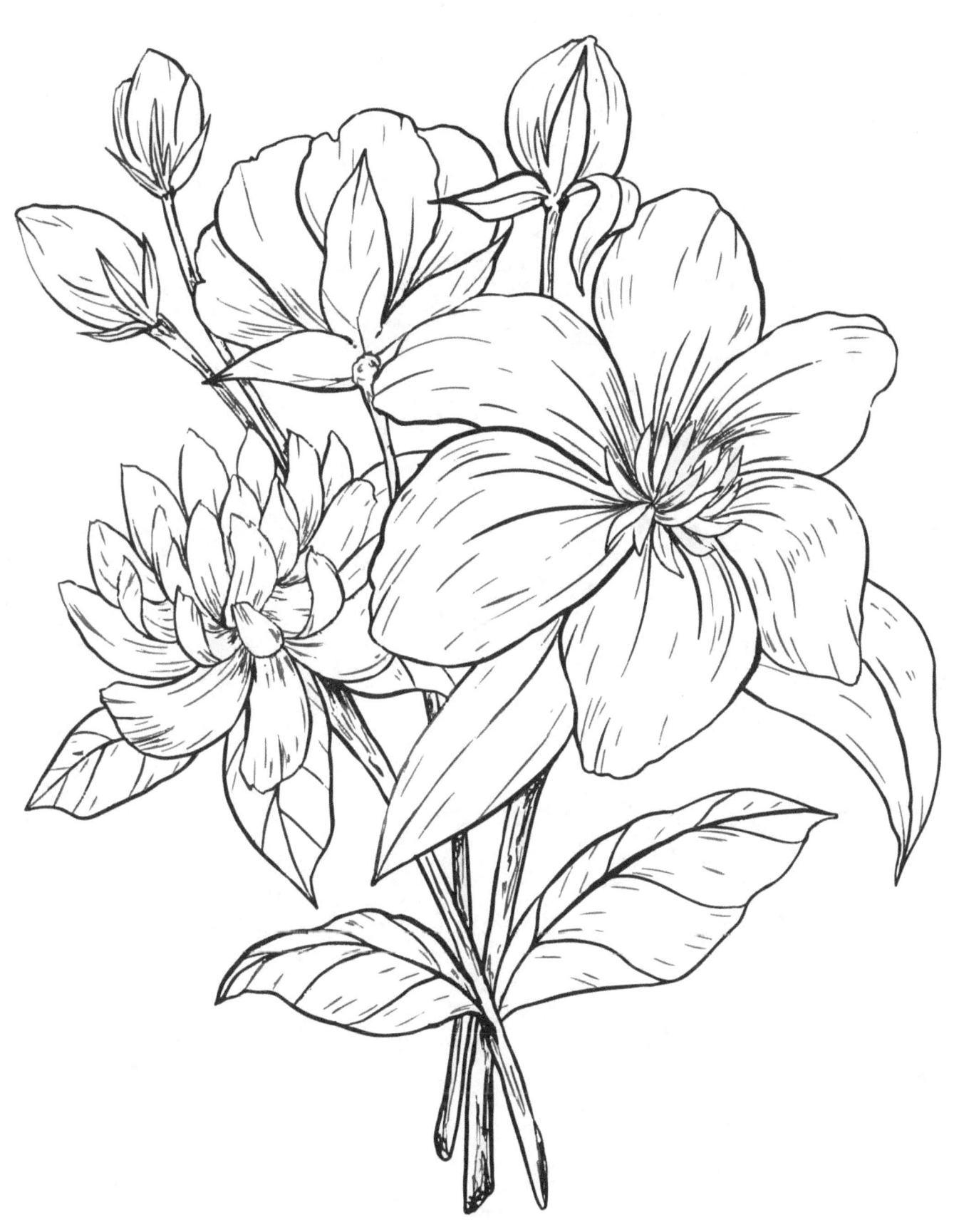

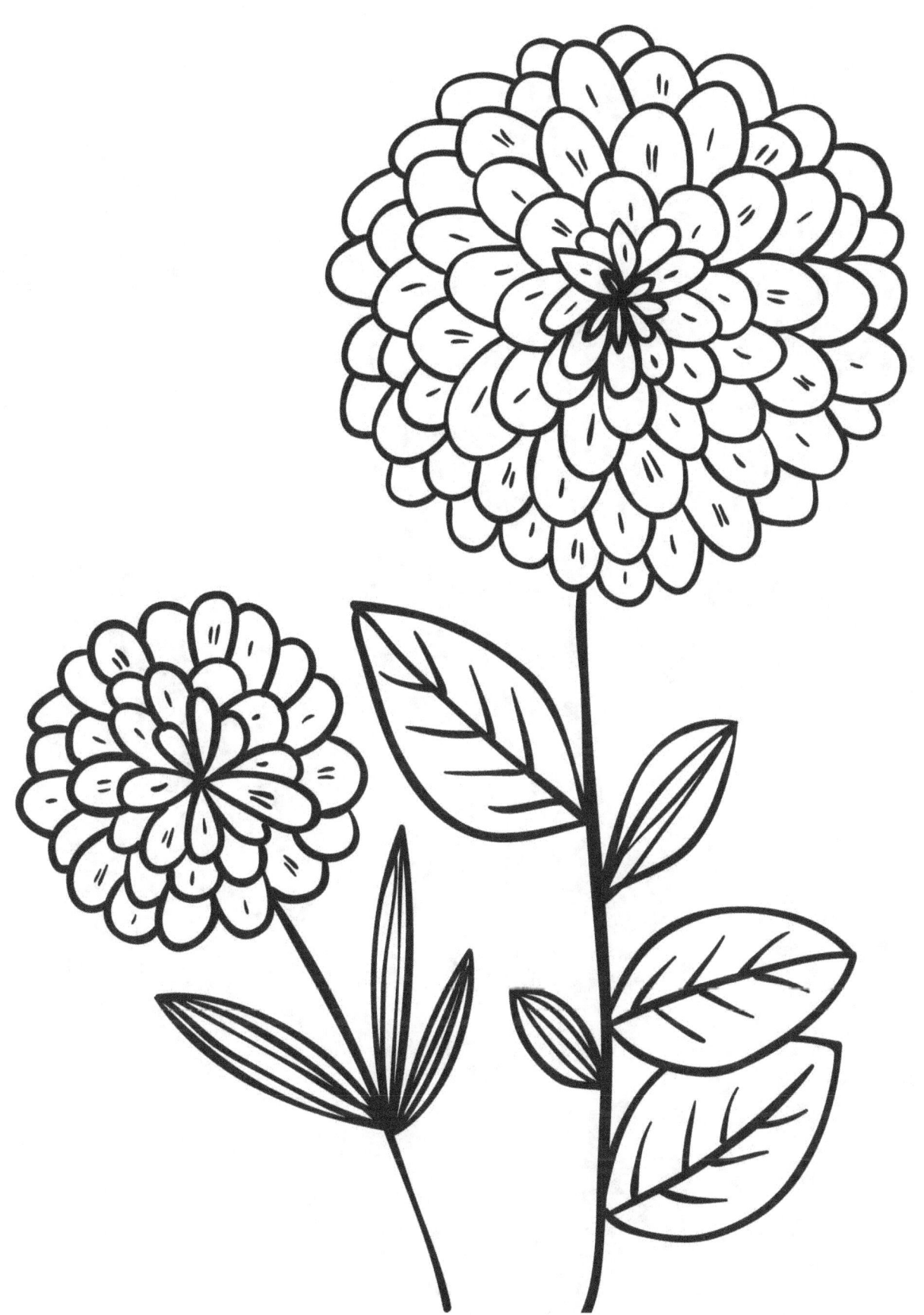

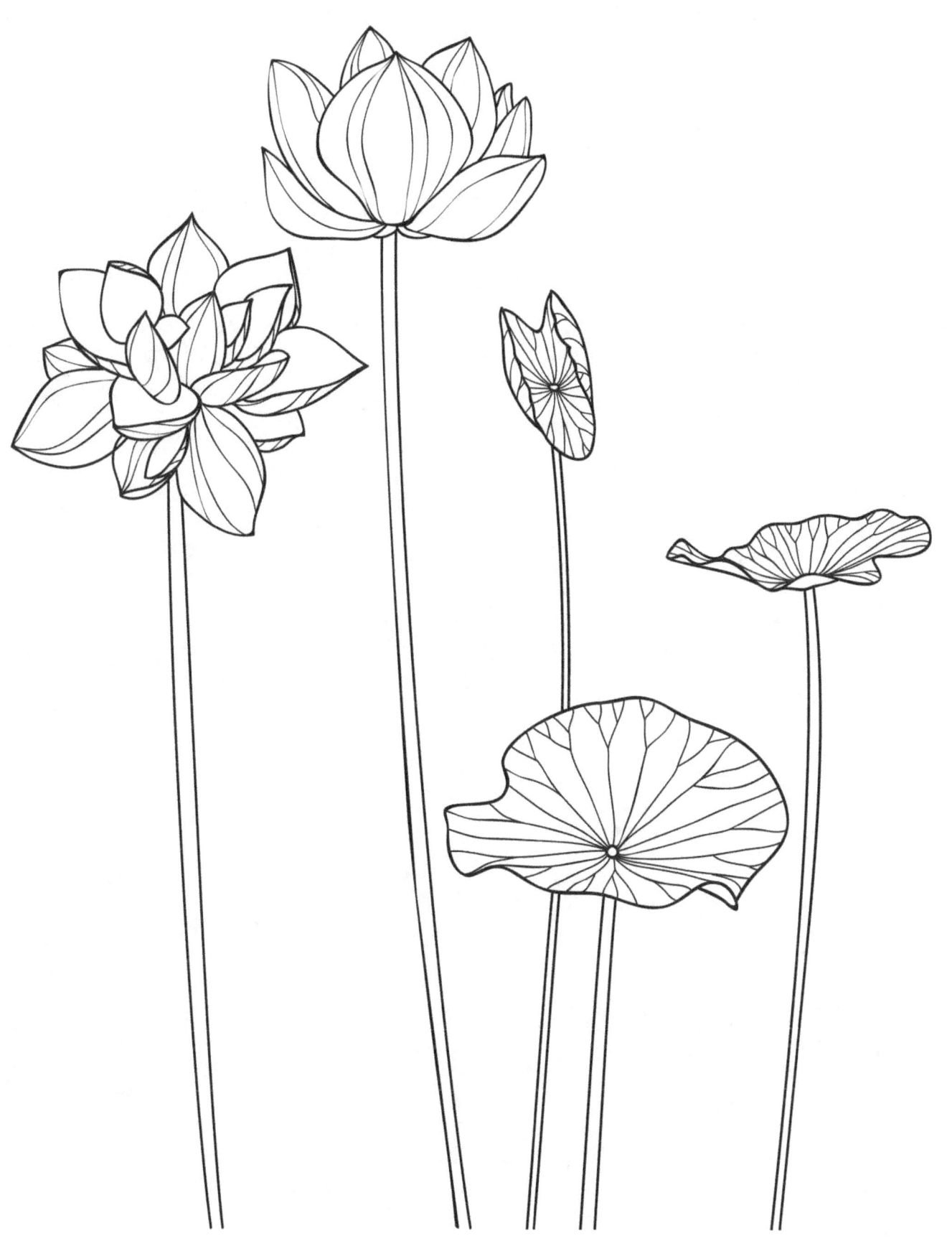

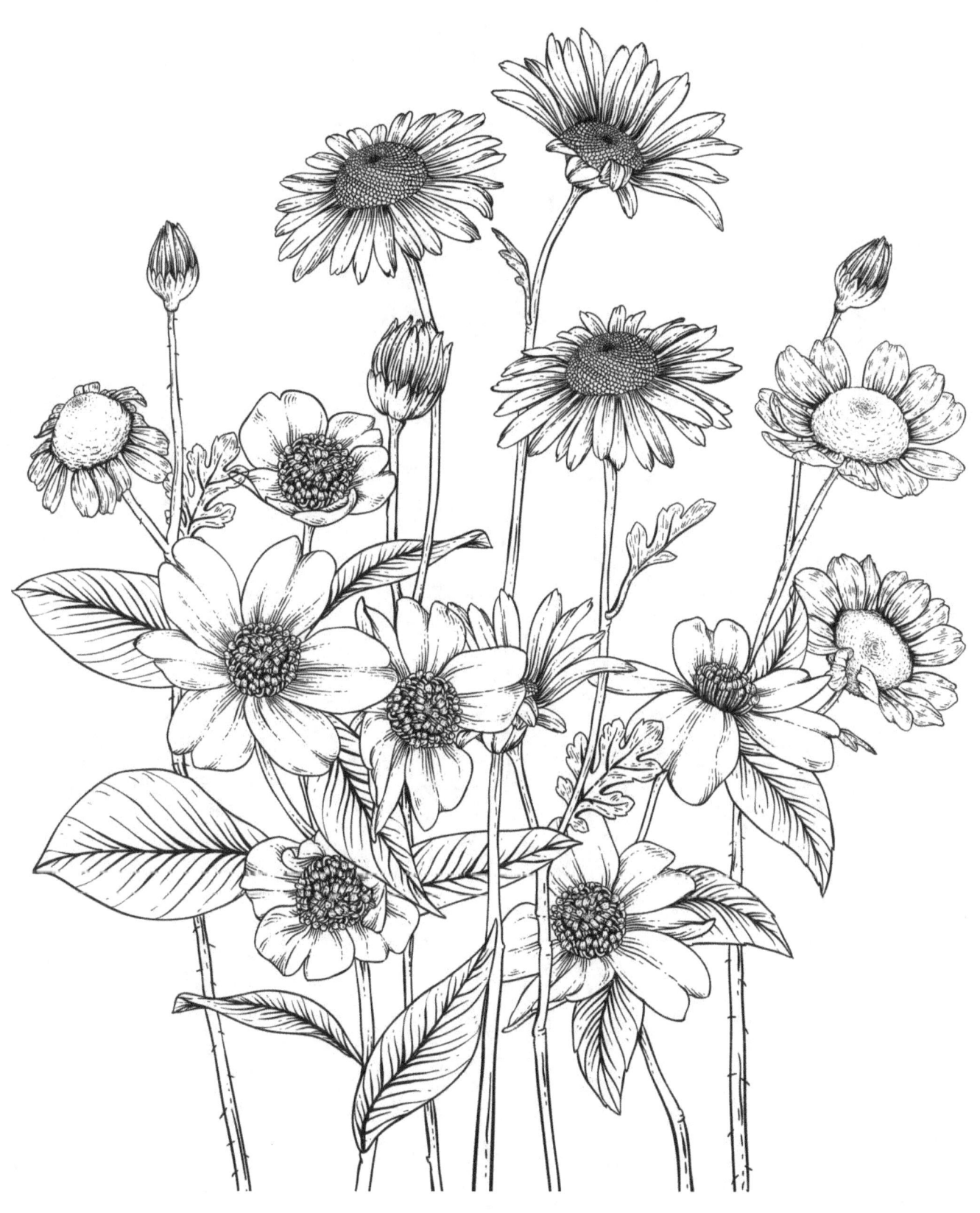

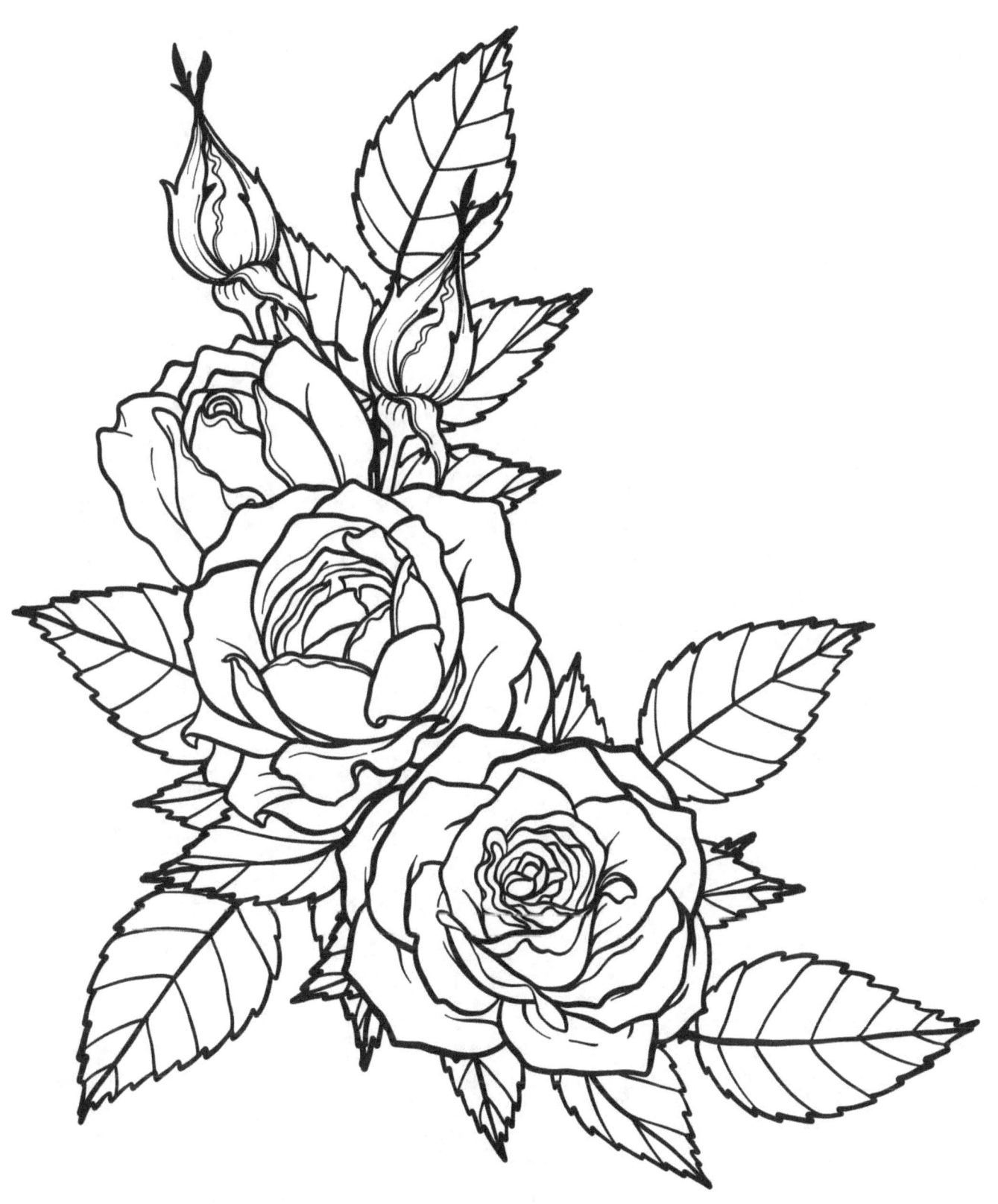

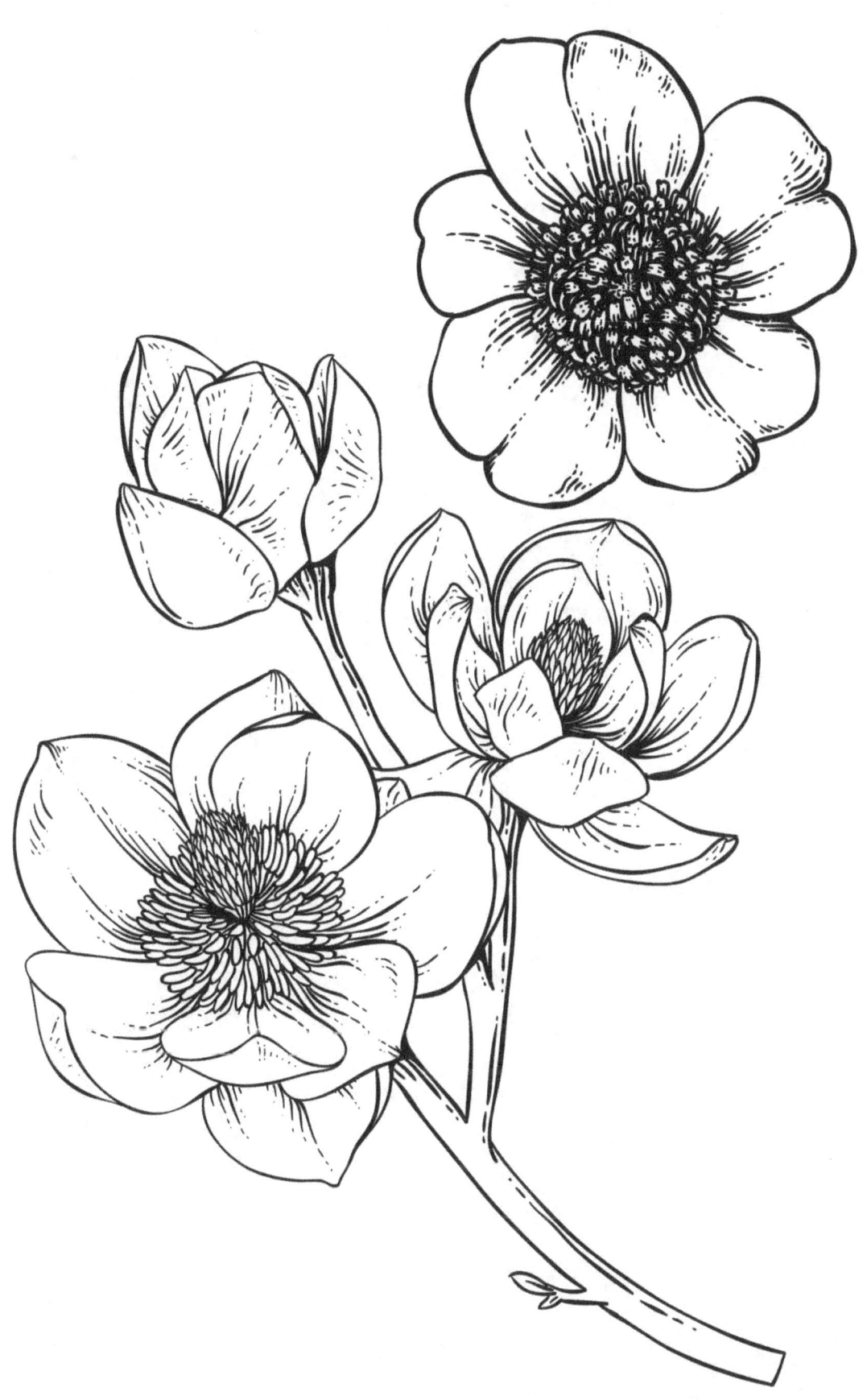

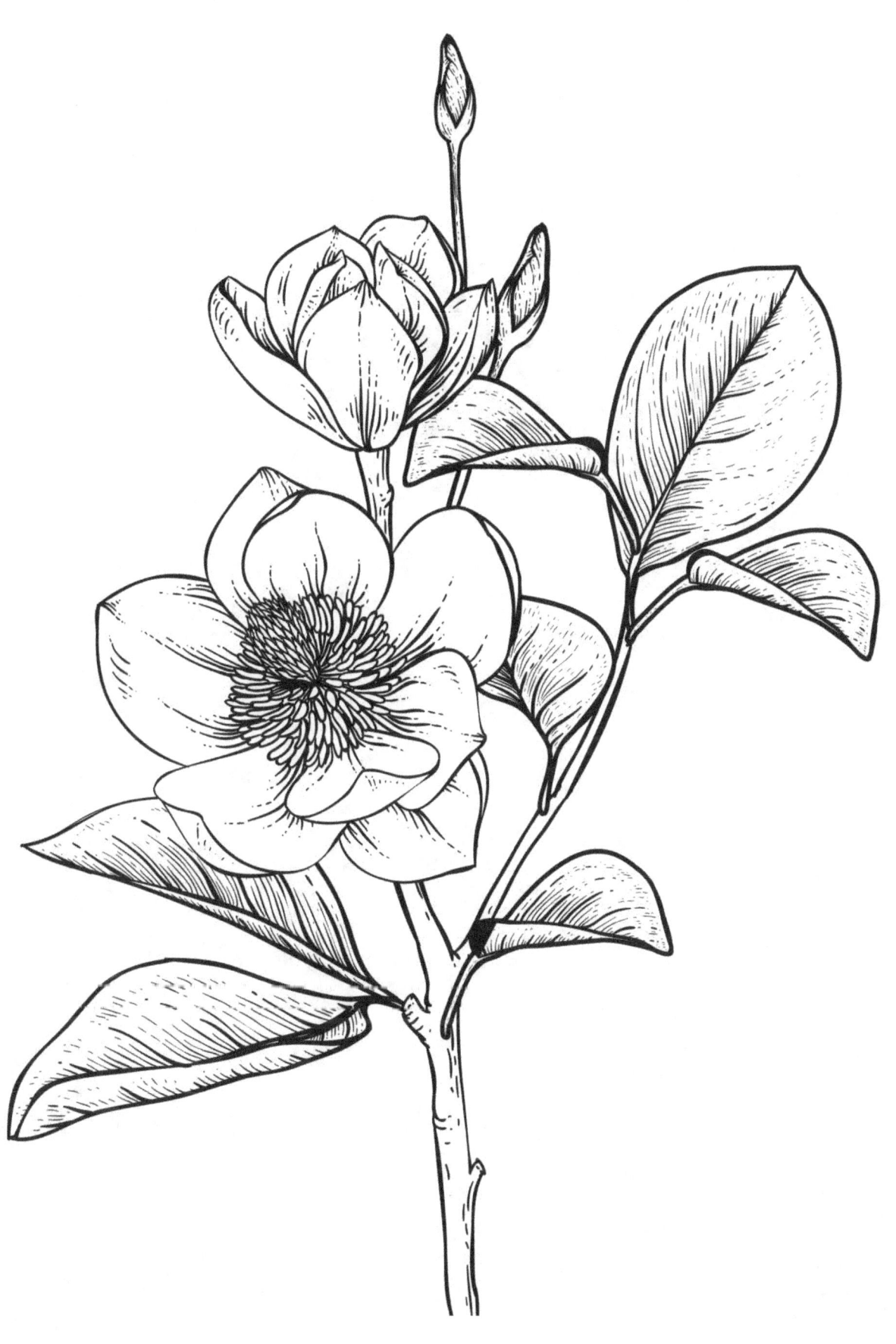

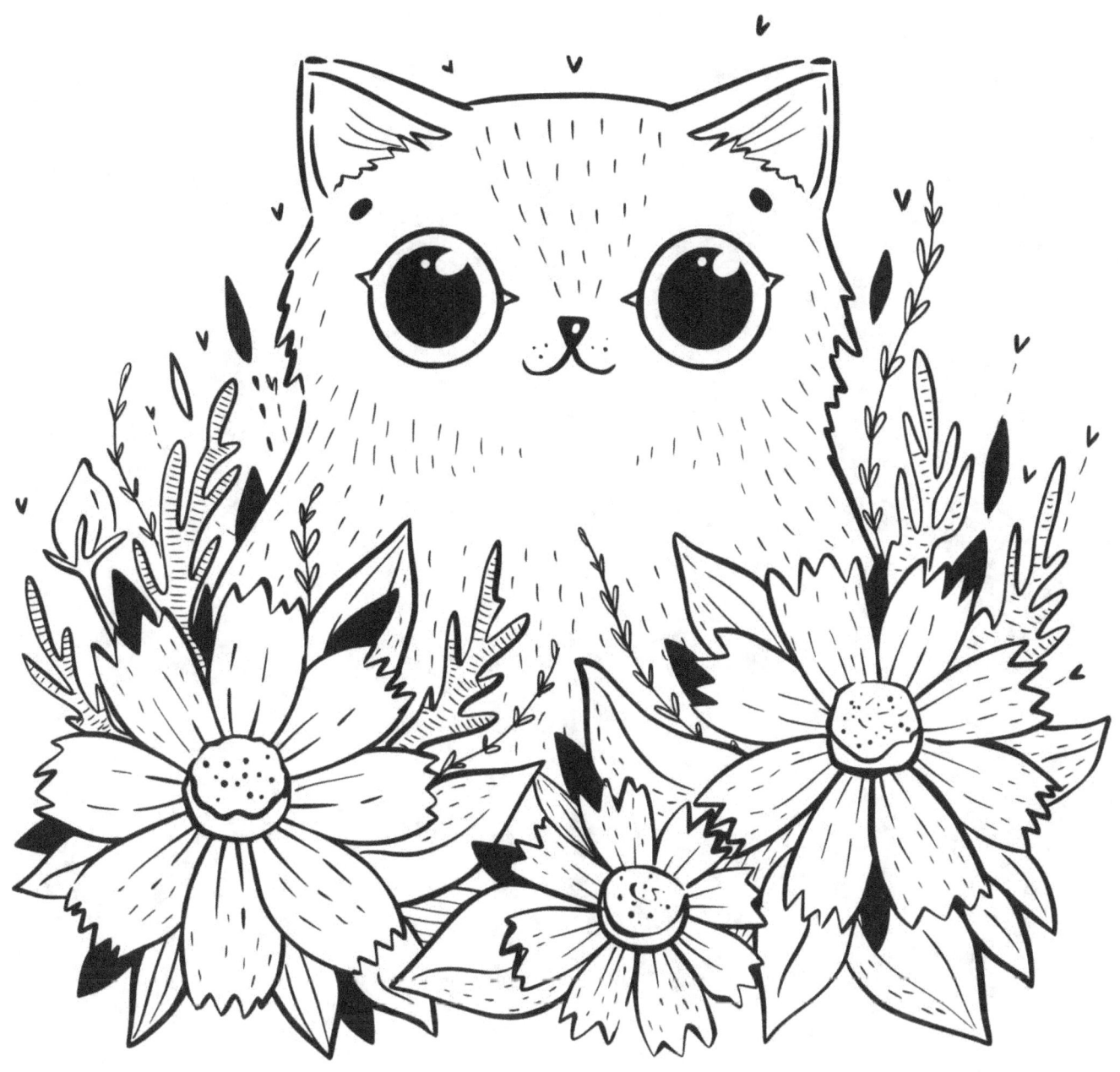

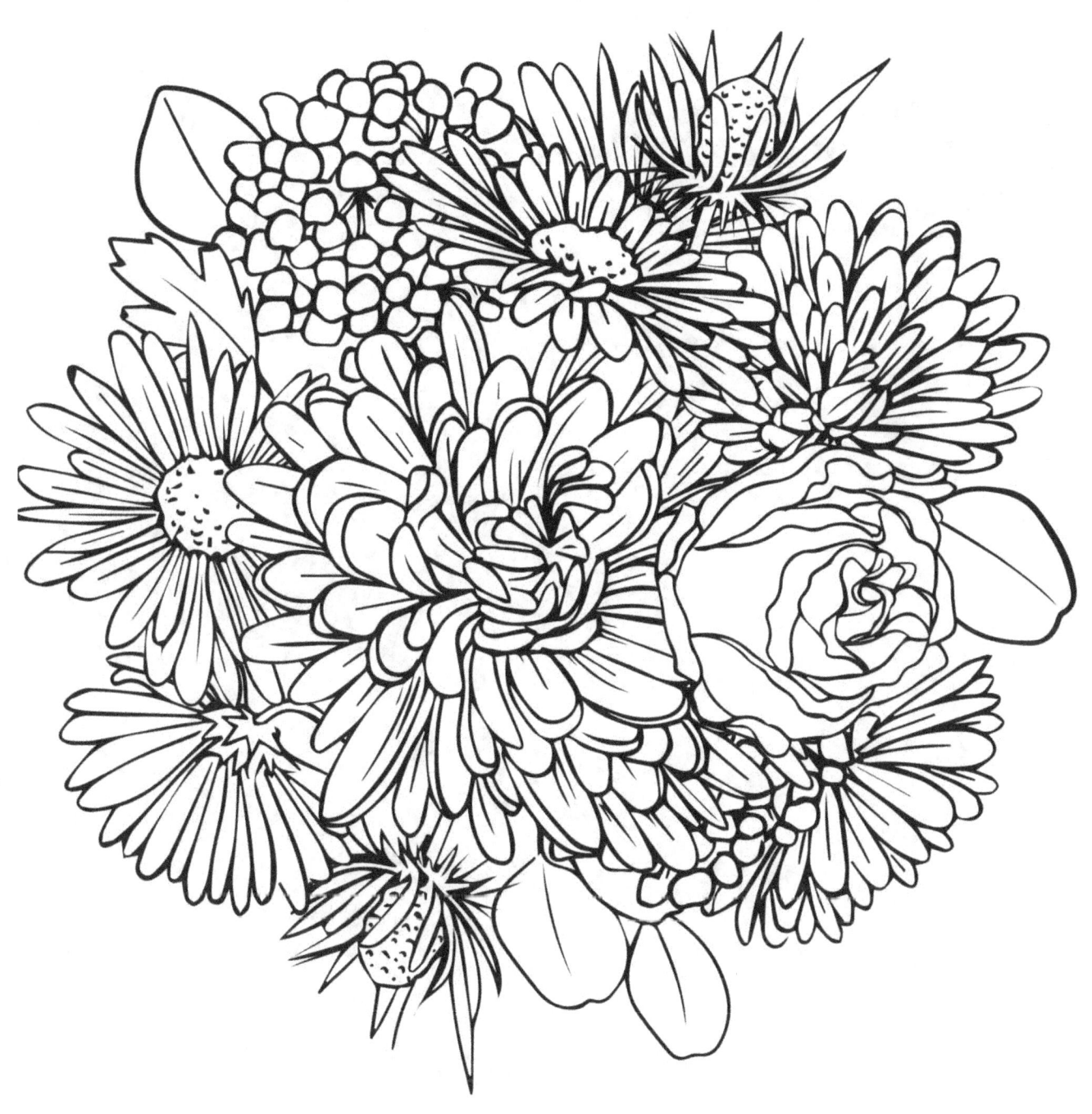

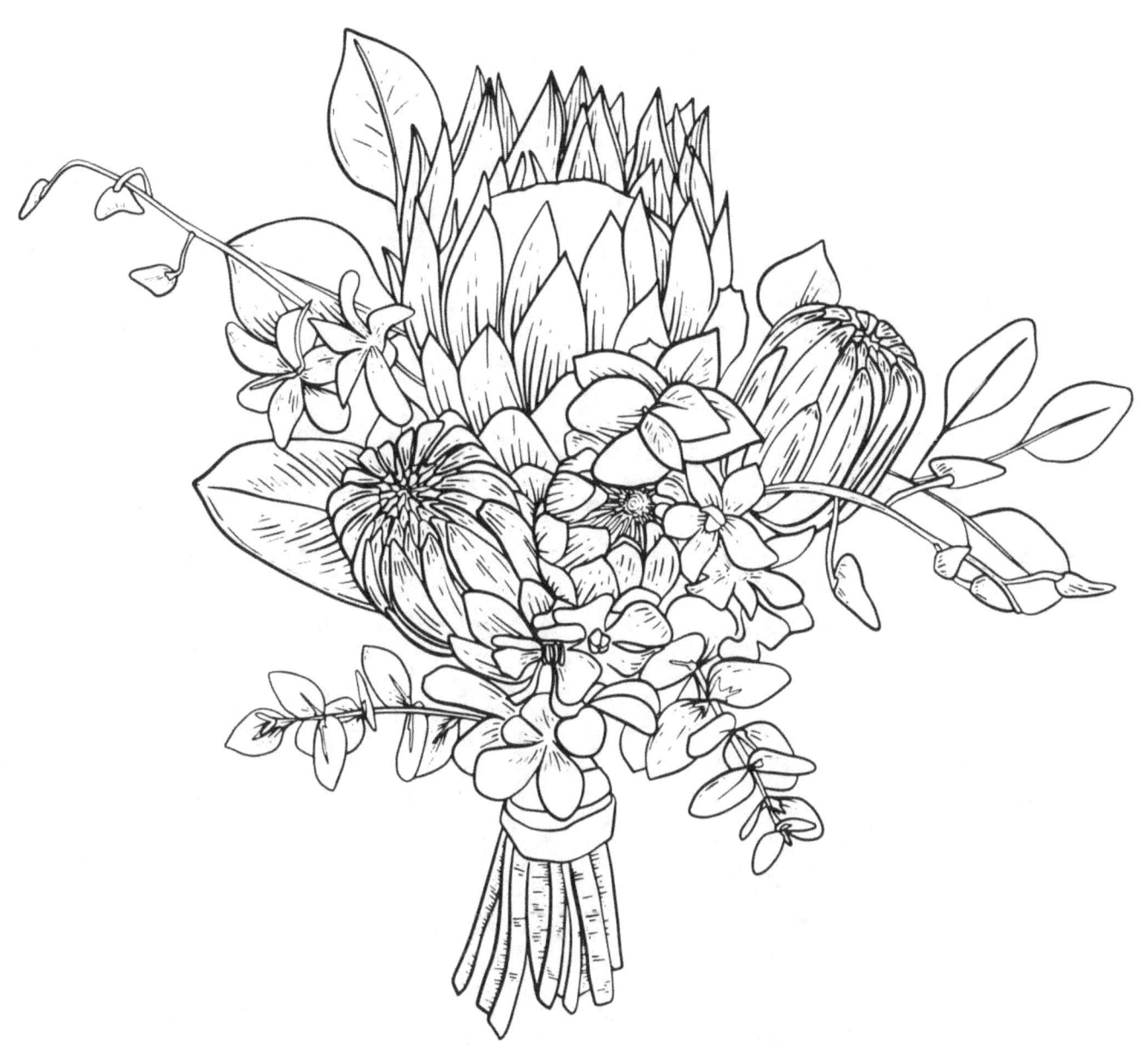

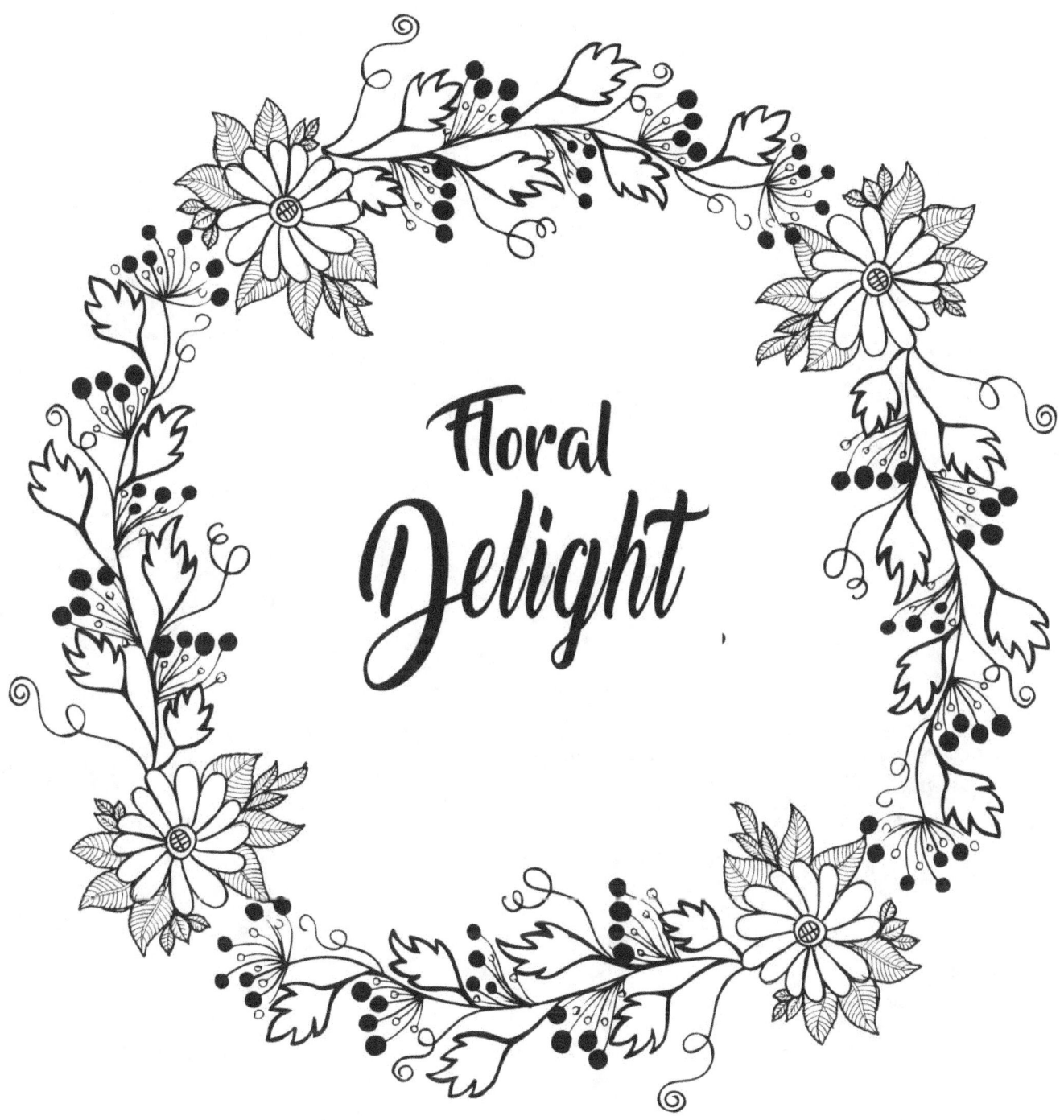

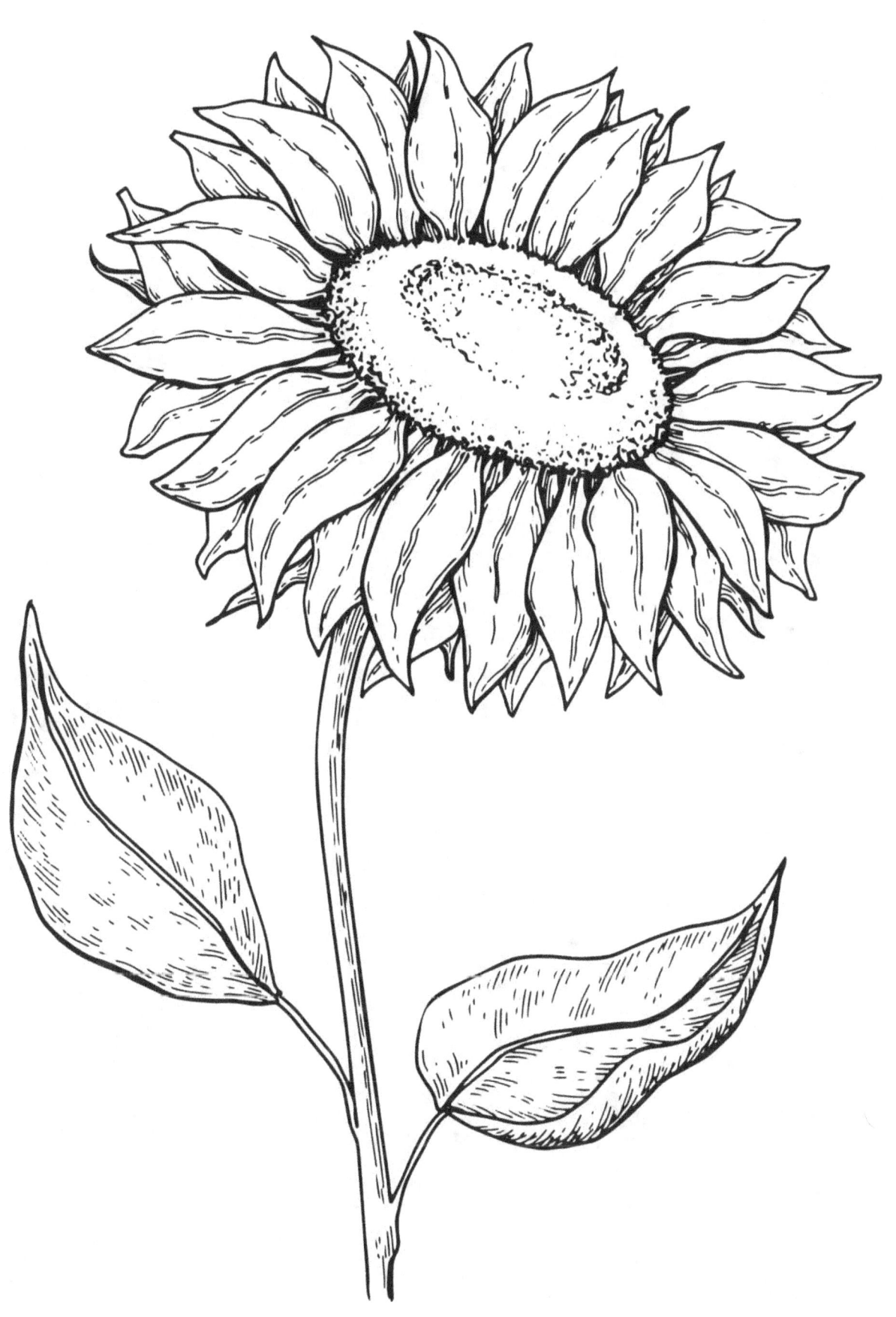

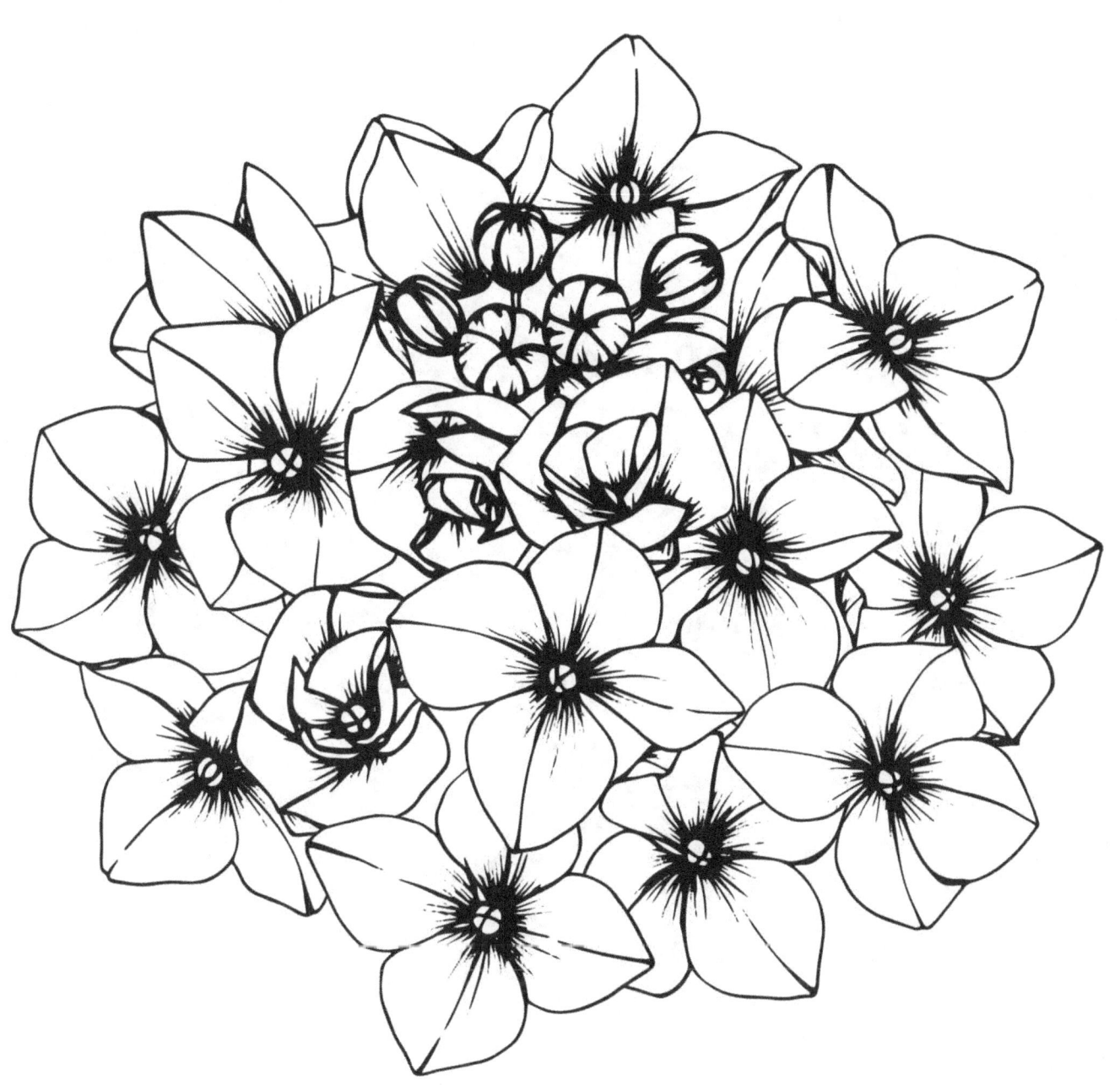

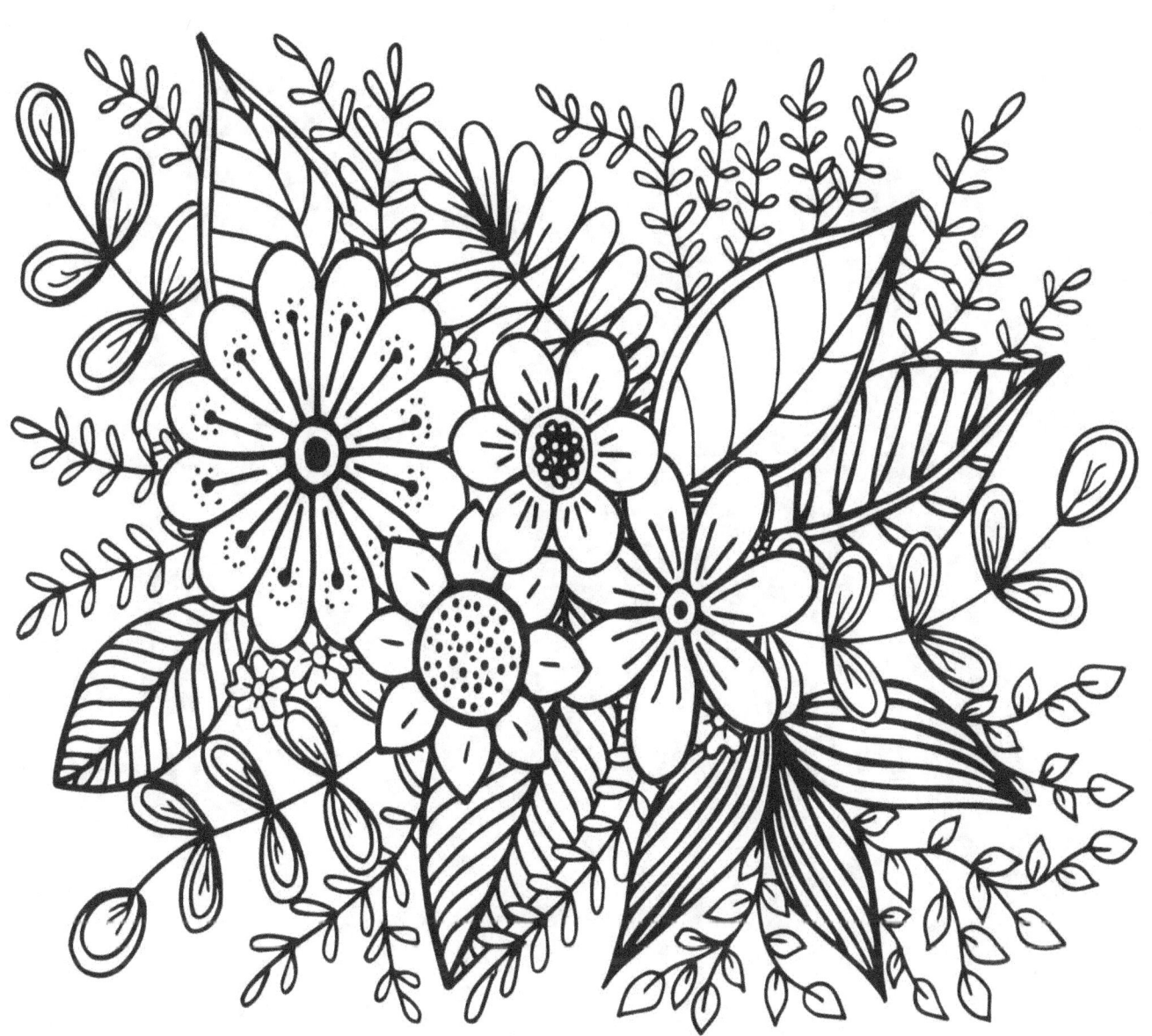

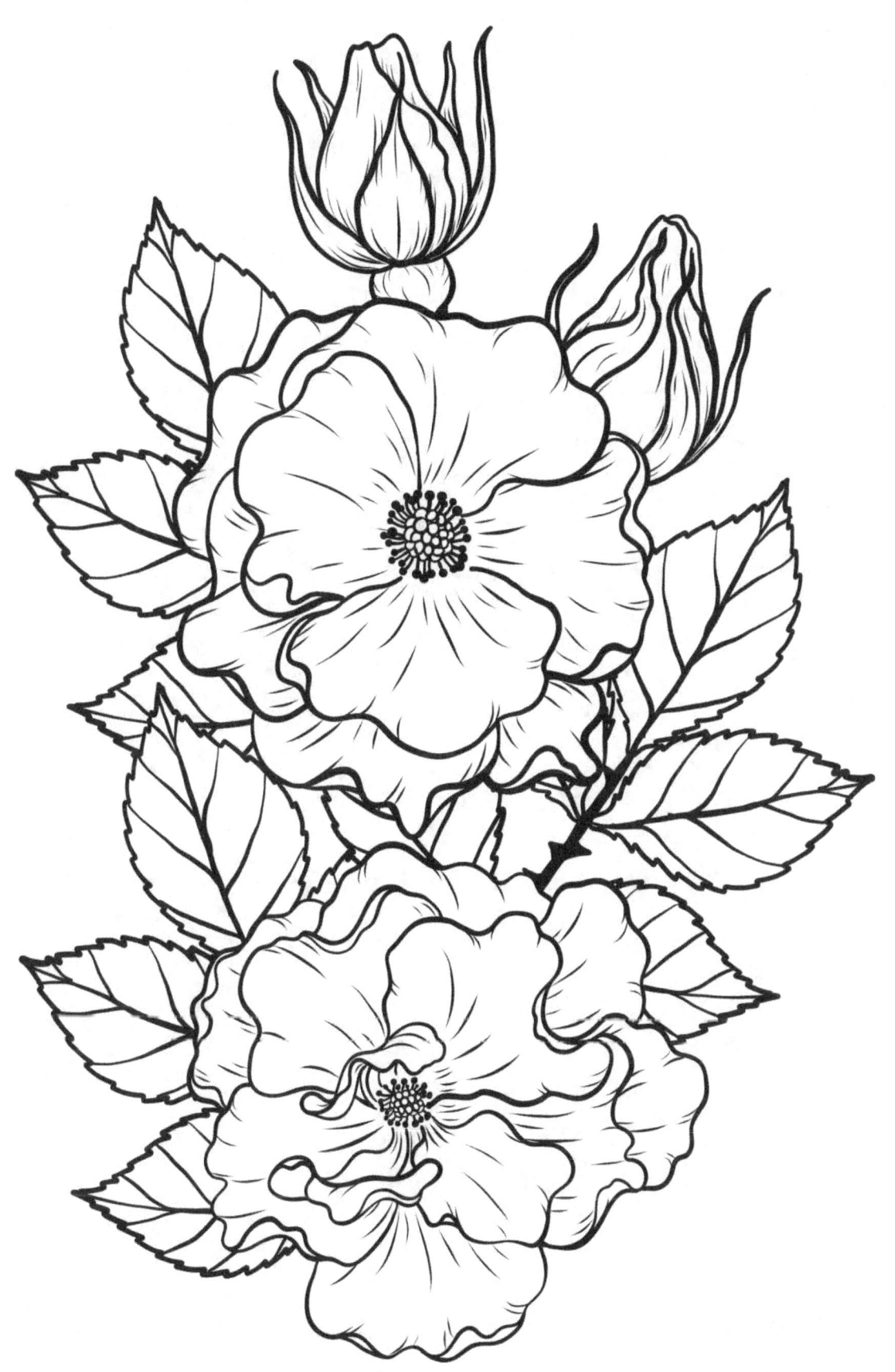

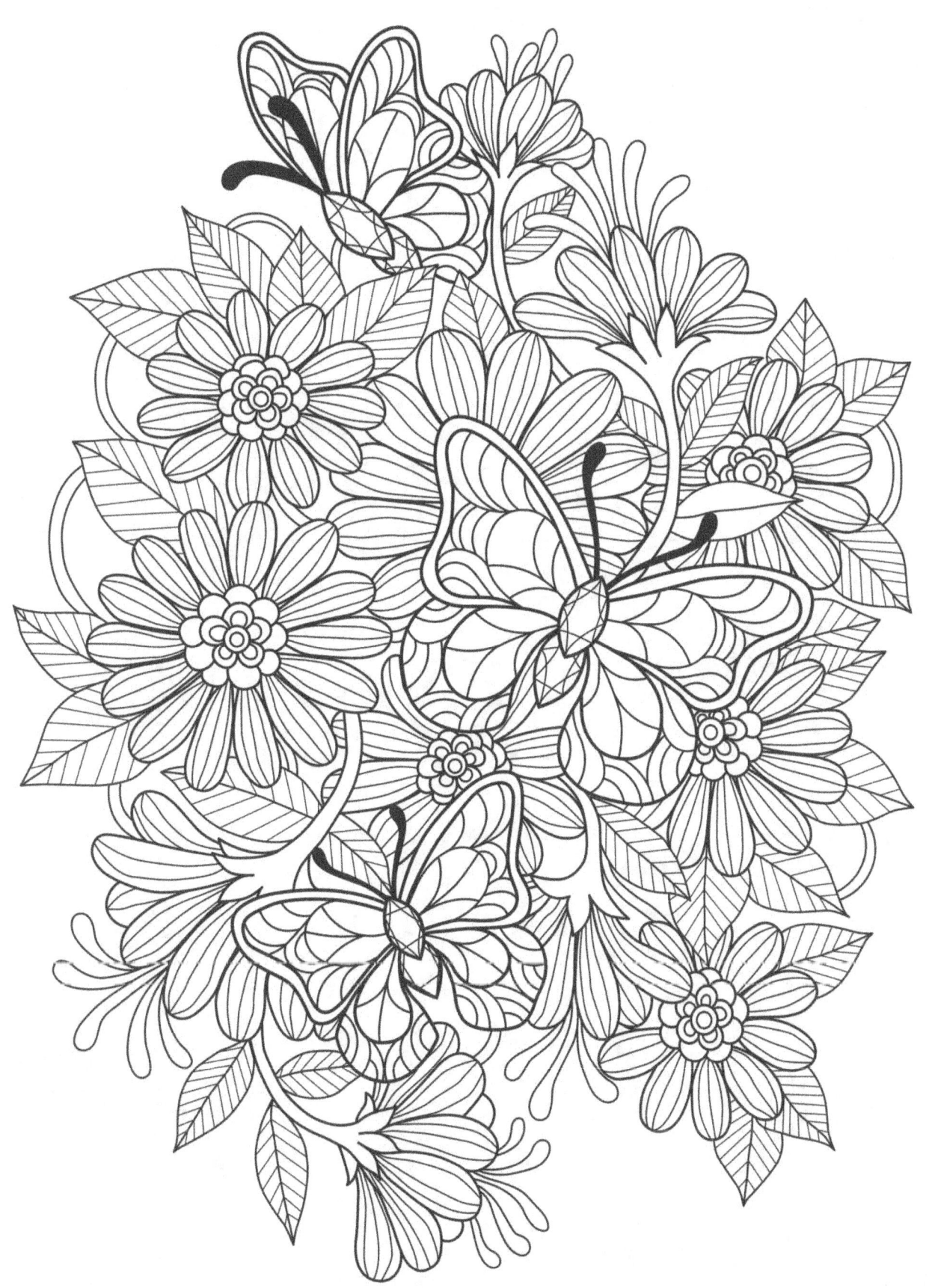

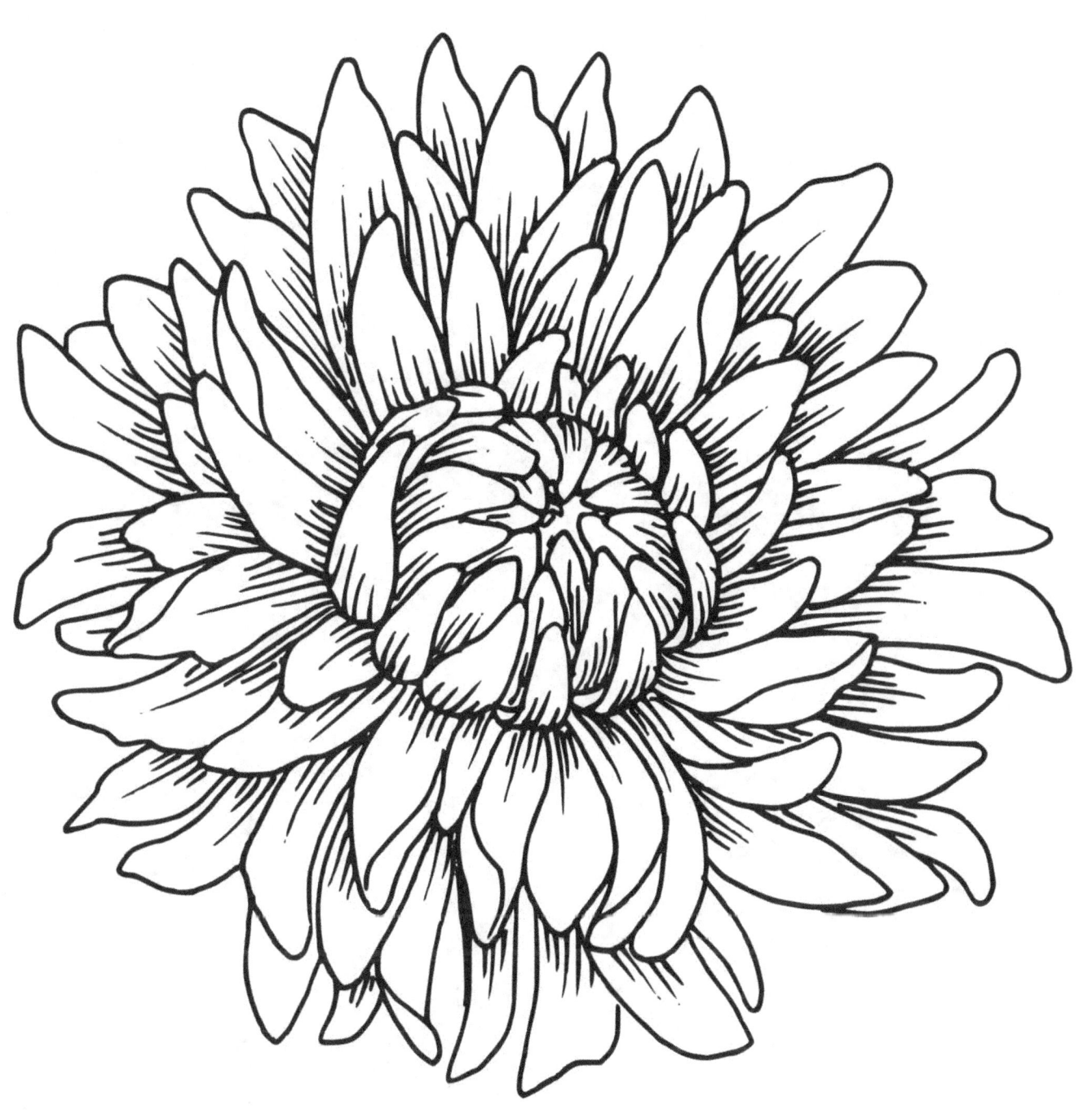

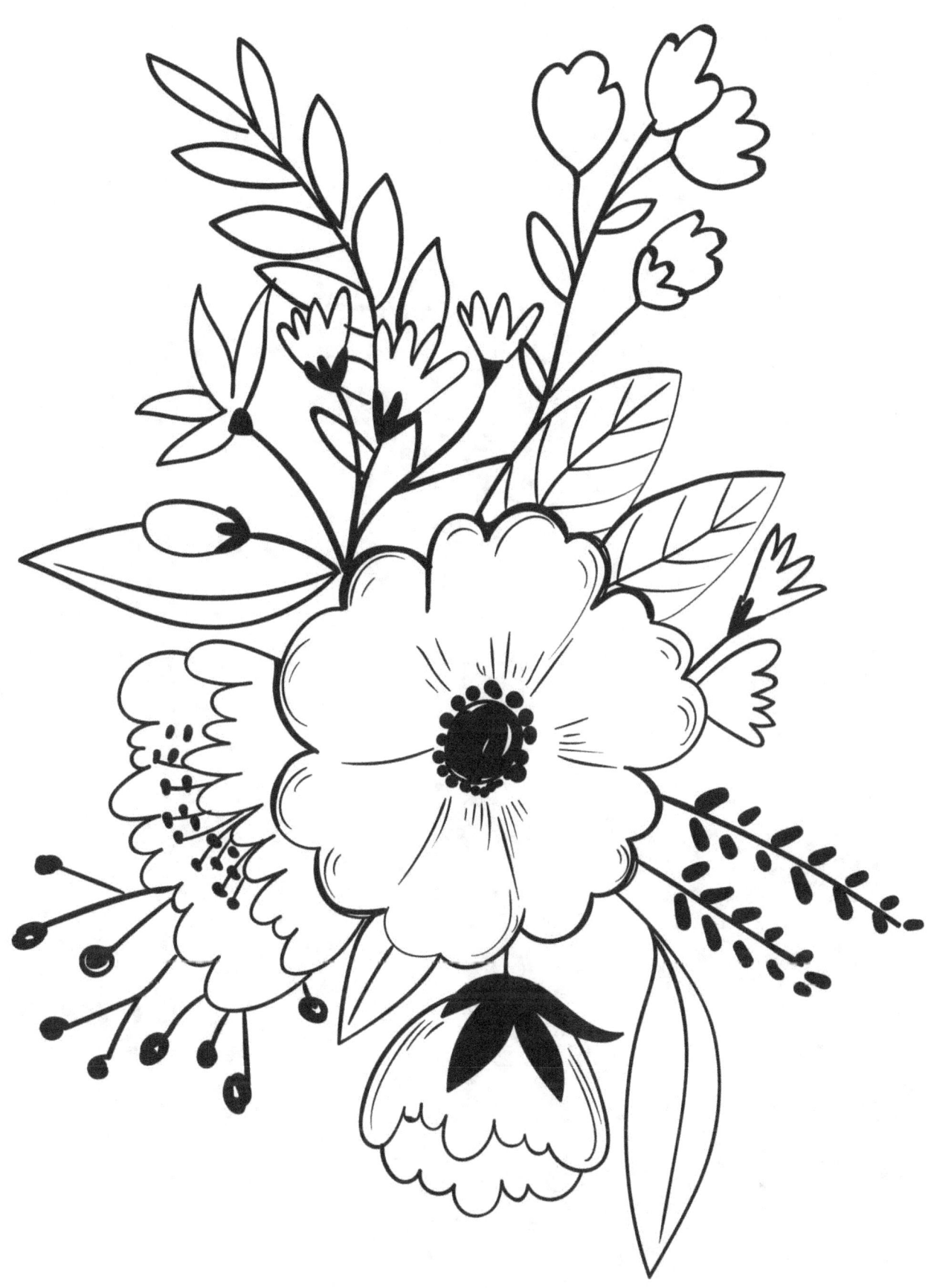

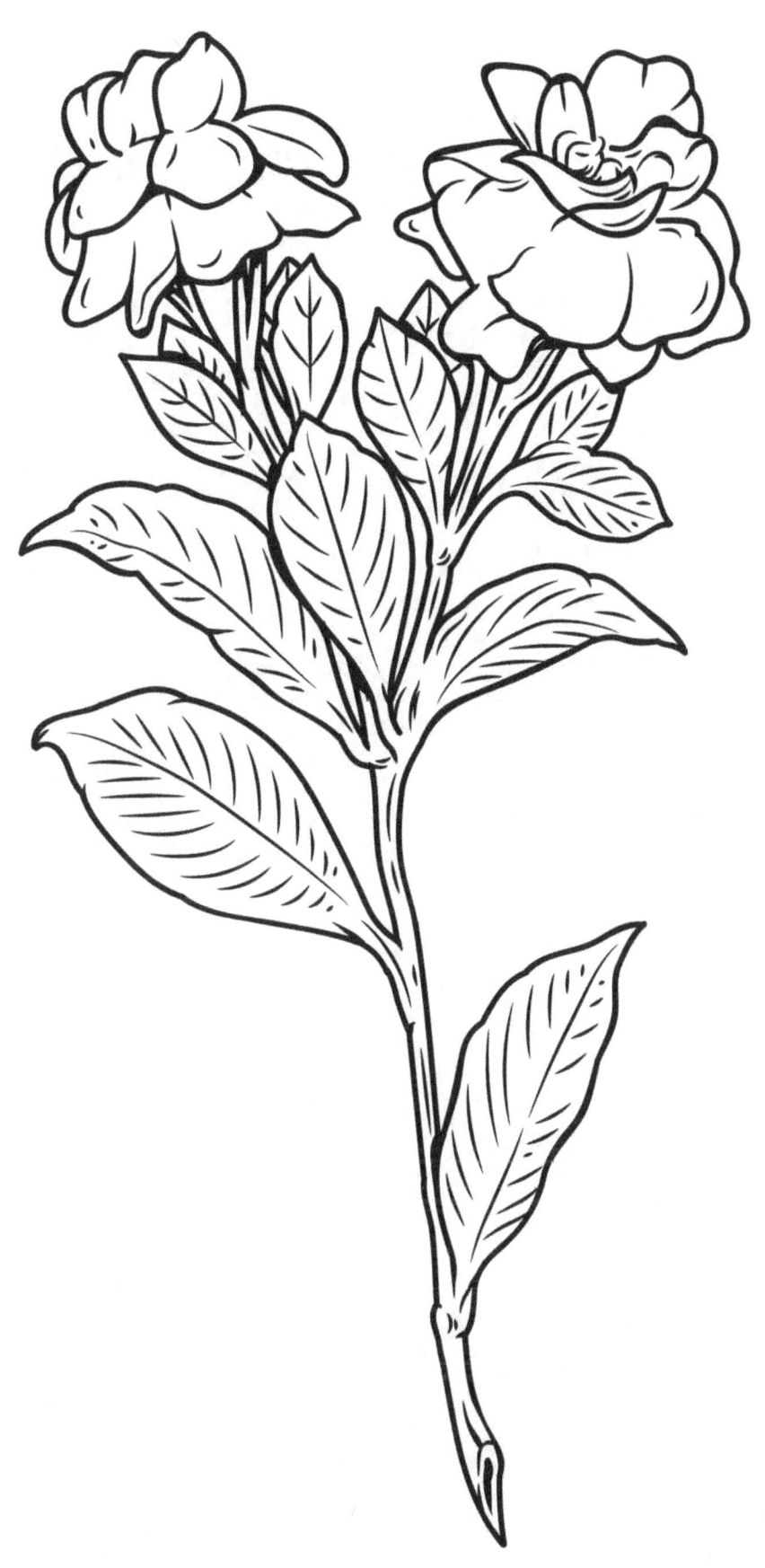

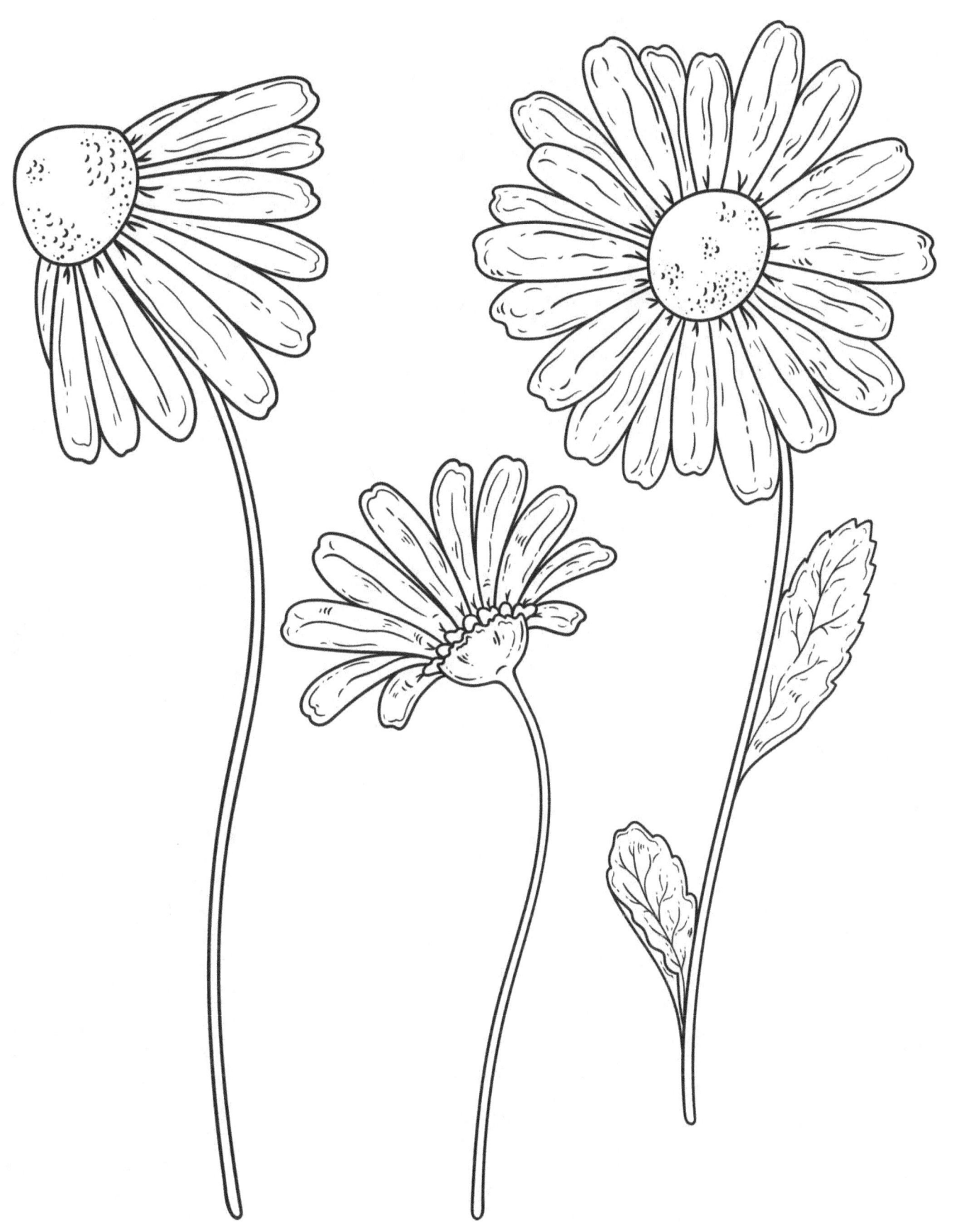

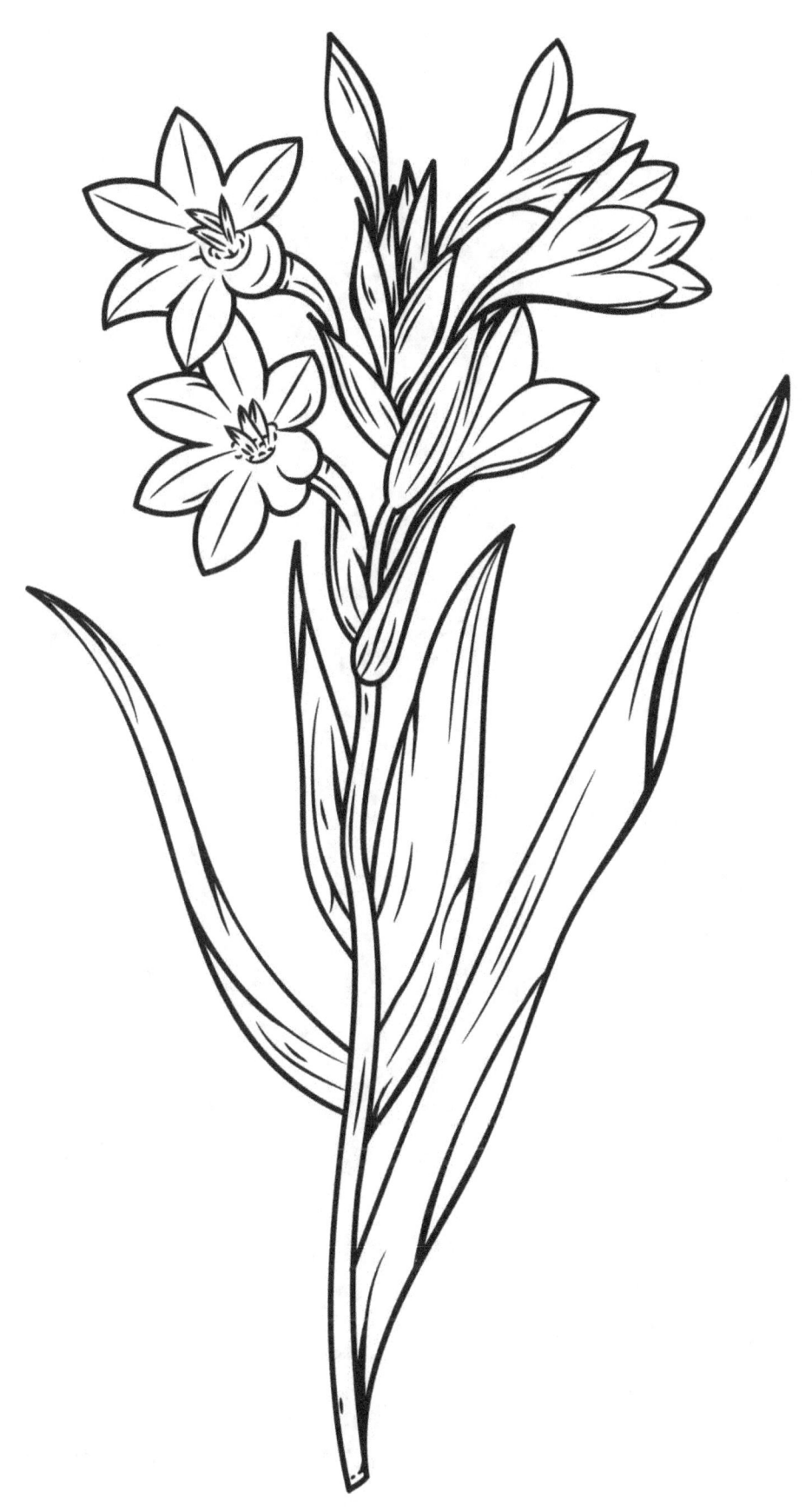

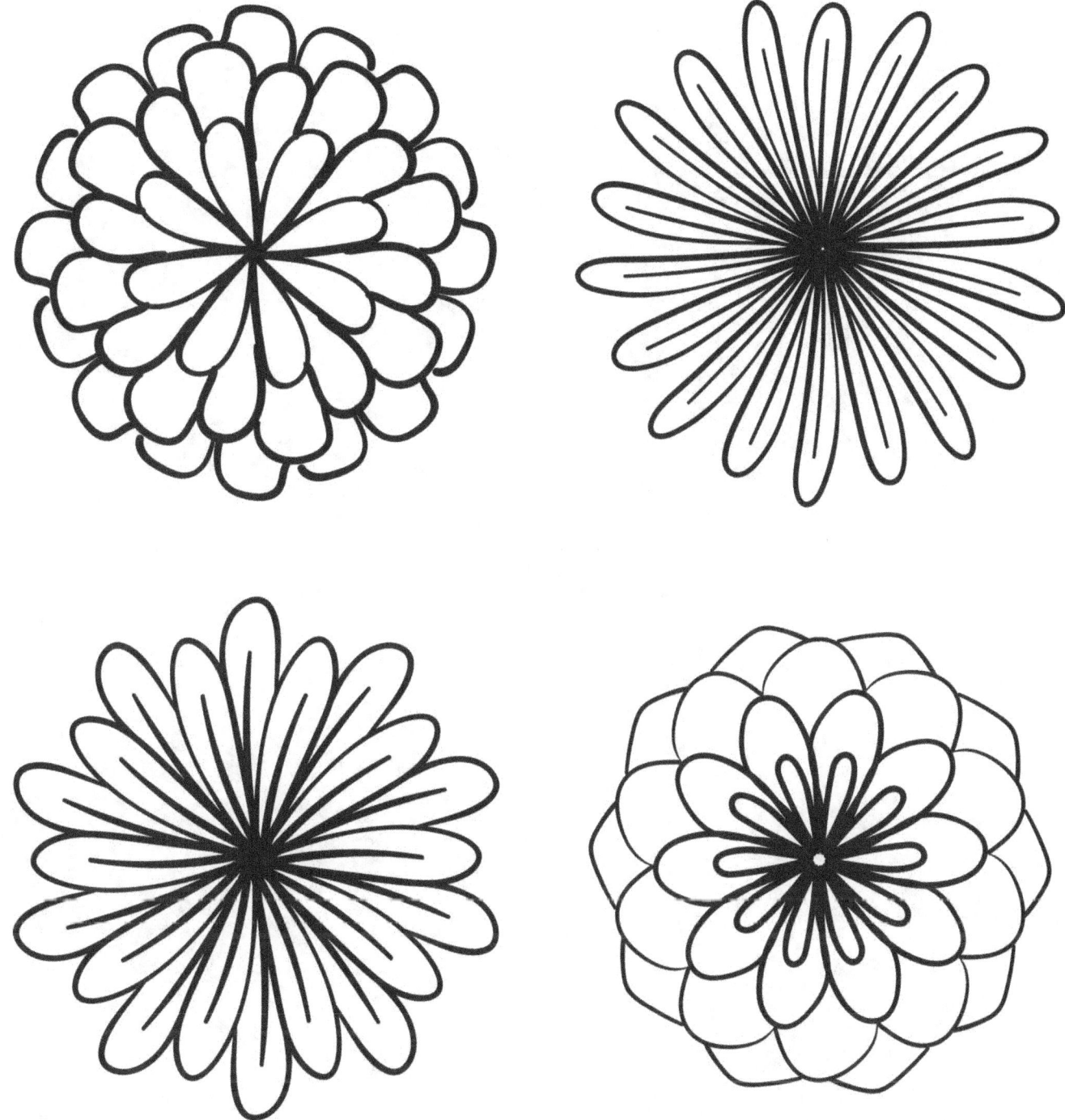

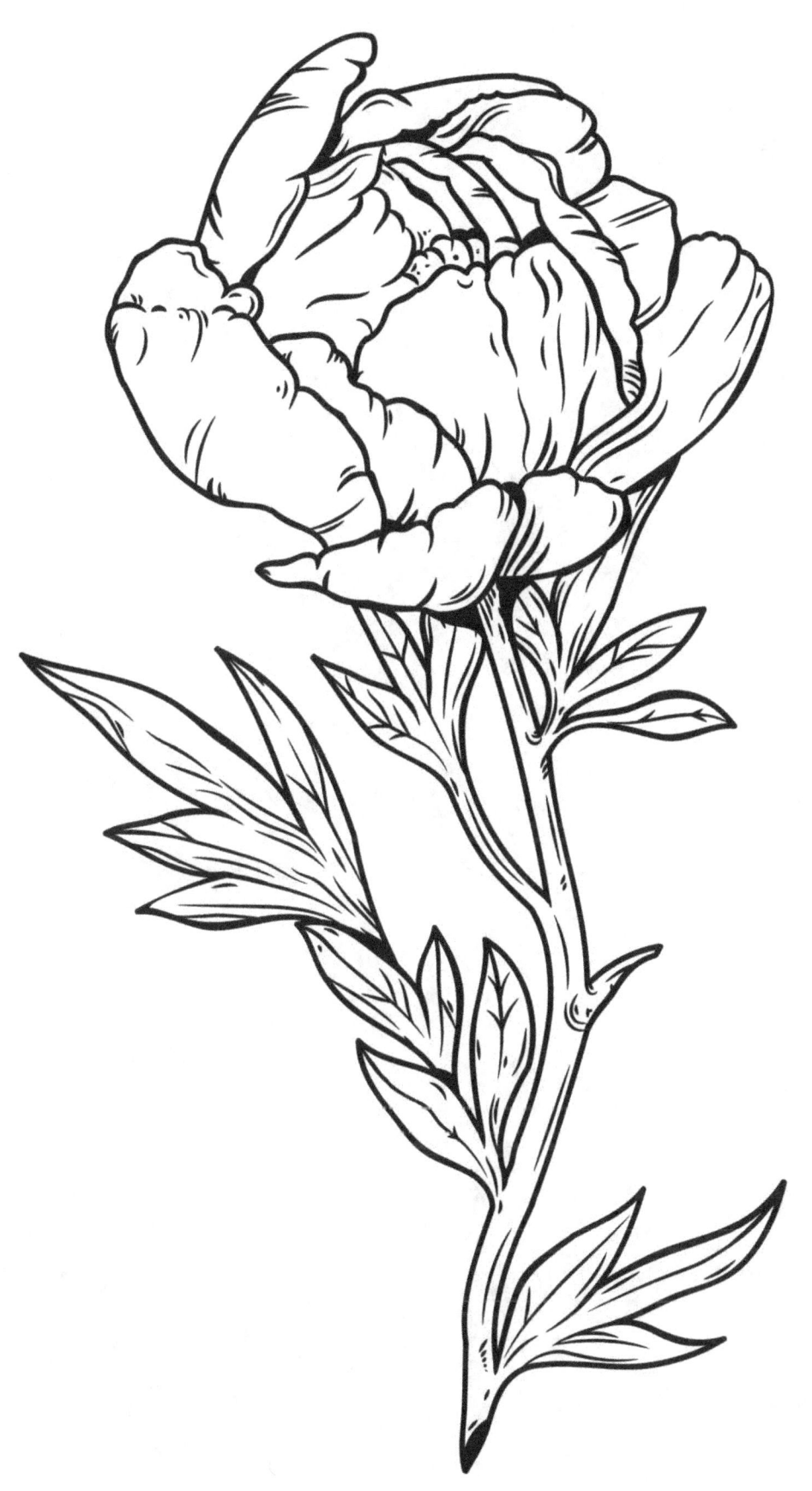